THE GLASS HOUSE

NATIONAL
TRUST
FOR
HISTORIC
PRESERVATION

National Trust for Historic Preservation
1785 Massachusetts Avenue, NW
Washington, DC 20036-2117
Tel: 202 588-6000 Fax: 202 588-6038
www.nationaltrust.org

Philip Johnson Glass House, a National Trust Historic Site
199 Elm Street
New Canaan, CT 06840
Tel: 203 594-9884 Fax: 203 594-9885
www.philipjohnsonglasshouse.org

© 2008 Assouline Publishing
601 West 26th Street, 18th floor
New York, NY 10001, USA
Tel.: 212 989-6810 Fax: 212 647-0005
www.assouline.com

Color separation by Luc Alexis Chasleries
Printed in China
Text © National Trust for Historic Preservation

ISBN: 978 275940 1673

THE GLASS HOUSE

FOREWORD BY CHRISTY MACLEAR
ESSAY BY DOROTHY DUNN
NATIONAL TRUST FOR HISTORIC PRESERVATION

ASSOULINE

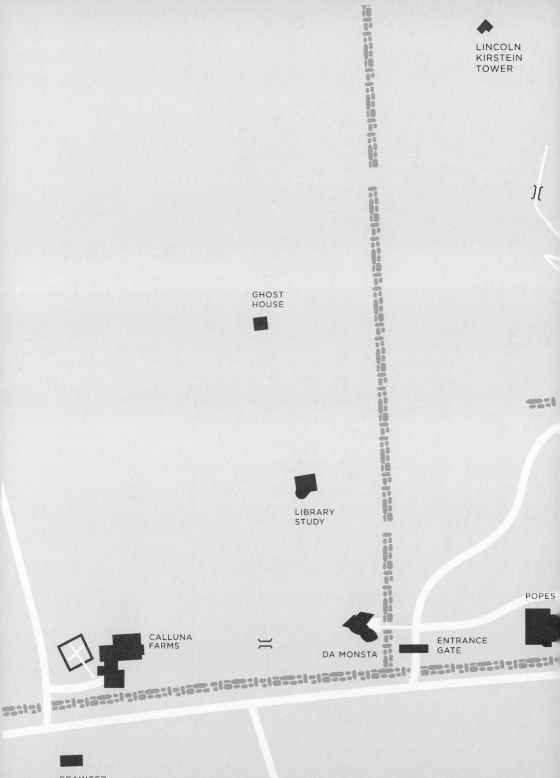

LINCOLN
KIRSTEIN
TOWER

GHOST
HOUSE

LIBRARY
STUDY

CALLUNA
FARMS

DA MONSTA

ENTRANCE
GATE

POPES

GRAINGER

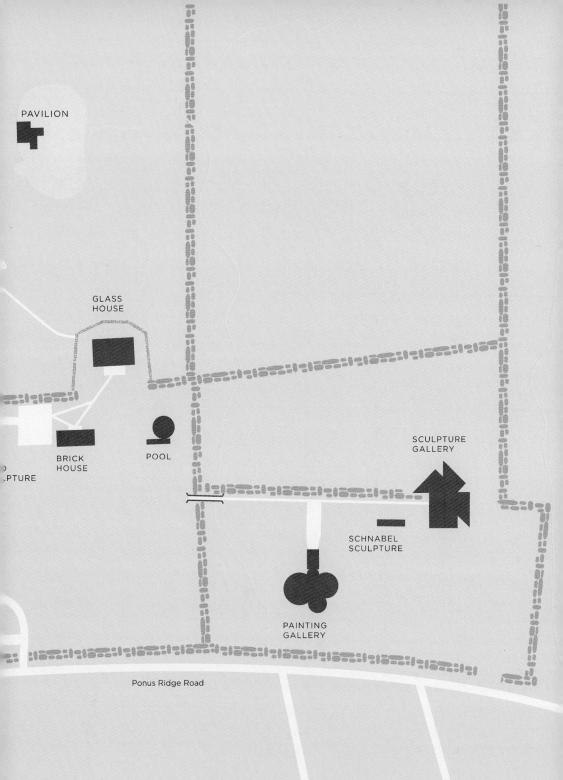

PAVILION

GLASS
HOUSE

SCULPTURE
GALLERY

BRICK
HOUSE

POOL

...PTURE

SCHNABEL
SCULPTURE

PAINTING
GALLERY

Ponus Ridge Road

Foreword

t his book shares the tour of the Philip Johnson Glass House in New Canaan, Connecticut, which opened to the public as a National Trust Historic Site in 2007.

Philip Johnson donated his iconic Glass House to the National Trust for Historic Preservation in 1986. The donation included the forty-seven-acre site, its fourteen structures, and the collection of artwork, all of which illustrate two lives dedicated to beauty, innovation, and change. In 2005, both Philip Johnson and David Whitney died—the former having lived a long life of ninety-eight years, and the latter having lived an all-too-short life of sixty-six years. David Whitney directed his estate to support the Glass House in perpetuity and to augment the collection of large-scale artworks that visitors see in the Painting and Sculpture Galleries. The generosity of these two men extends beyond the donation of the site and collections to the investment they both made in the careers of architects, artists, and designers. This investment in the future is demonstrated by the buildings, inspired by emerging talent, and the artwork, collected through their friendships. Therefore, the mission of the Philip Johnson Glass House is to lead, in discussion and in action, initiatives to preserve modern architecture, art and landscape design; and to cultivate new ideas and creative talent, honoring the spirit of Philip Johnson and David Whitney.

The National Trust for Historic Preservation is a private, nonprofit membership organization dedicated to saving historic places and revitalizing America's communities. Founded in 1949, the same year the Glass House was completed, NTHP provides leadership,

education, advocacy, and resources to protect the irreplaceable sites that tell America's story. NTHP is also a steward of Mies van der Rohe's modern masterpiece, the Farnsworth House in Plano, Illinois. This, together with the Glass House, helps NTHP launch a new chapter in the preservation and interpretation of modernism. New initiatives will promote research, policy, awareness and documentation to build and support a growing community of interest around modern stewardship and preservation.

The Glass House will never become a somber memorial, frozen in time; it will remain a dynamic experience of place. Through this site, innovation will be promoted, talent will be cultivated, and a new generation of modern preservationists will grow.

Beyond the direct engagement with architecture, art, and landscape offered by the tour, I want to pay homage to Philip Johnson's and David Whitney's generosity and inspired patronage, which has placed this unique site into the hands of the public. The Glass House redefines the historic house museum, offering a context for the past as a source of inspiration for the future.

Christy MacLear
Executive Director
Philip Johnson Glass House
National Trust for Historic Preservation

A Journey through the Glass House

t he Philip Johnson Glass House affords a rare opportunity to become fully engaged in the realization of a singular design vision and to directly experience Philip Johnson's passion for exploring the relationship between architecture and landscape. Most guests arrive with some previous knowledge of Philip Johnson: They may know he was the founding director of the Department of Architecture at The Museum of Modern Art and one of the most powerful cultural catalysts of the twentieth century. They may be familiar with his buildings and recognize him as the "dean of American architecture." Perhaps they have attended one of his legendary lectures or studied books and essays about his work. Regardless, guests soon realize that the experience offered by the Glass House—a forty-seven-acre country estate with fourteen separate structures—is a revelation.

Architects and designers are aware that there are important distinctions between design and art, including the parameters set by the client, the budget, and the necessity to meet a need or serve a function. Philip Johnson was free of all of these parameters, as, over the course of fifty years, he designed and shaped his New Canaan property. He was his own best client. He was independently wealthy. He emphasized the emotional impact of the experience of place over need and function. Philip Johnson called the Glass House "my fifty year diary." A guest countered, "The Glass House wasn't Johnson's diary, it was his opera!" The Glass House was Johnson's canvas for living; a place where he explored new ideas, took risks, and embraced the dynamic constancy of change, both in nature and in the realm of ideas. For more than thirty of these years, he shared the site with his partner David Whitney, an influential art curator and patron.

Philip Johnson began envisioning a glass house in 1945, and purchased a five-acre property in New Canaan, Connecticut, in 1946. He completed his modern country home in 1949. He explained, "I began the design of the Glass House with the driveway." The property's entrance is marked by a monumental postmodern gate that was built in 1977. The gate is dramatic and conveys to all who enter, "You have arrived."

Johnson was adamant that he made no distinction between architecture and landscape architecture. The experience of the Glass House is a sequence of choreographed moments, shaped by design, that engage your senses as you move through and between the architecture and the landscape. Johnson called this "procession." The procession begins at the top of the driveway where, after the entrance gate, you are surrounded by an enclosure created by a planting of white pine trees. These trees create a colorful, fragrant vestibule. As you stroll down the driveway, leaving this space, a view of an open rural landscape is revealed, with stone walls, meadows, and distant forests.

Pavilions and follies are carefully positioned in the landscape. Johnson called these "events on the landscape," placed to draw and focus your view. One structure is Johnson's Library Study (1980). Johnson's extensive architectural book collection is inside this "monk's cell." Skylights brilliantly illuminate the space, allowing visitors to read the spine on every book. As with all great scholars, to know the man, you must know the mind, and to know the mind, you must know the library. Johnson was a voracious learner and his library reveals the breadth and depth of his interests and knowledge. Observation reveals a lack of formal pathways leading to the Library Study. Johnson explained, "By not having a path, I see something new every time I go to work."

Another structure, "Ghost House" (1984), is a folly. Influenced by the writings and work of his friends Robert Venturi and Denise

Scott Brown, Johnson employed a form reflecting the iconic shape of "house," a square topped by a triangle. Johnson was also inspired by his great friend Frank Gehry's use of common construction materials in architecture and he created Ghost House from chain-link fence. Now covered by honeysuckle and Virginia creeper vines, it practically disappears into the landscape. Before you continue the stroll down the drive, you are invited to pause, to look, to take it all in. You are surrounded by Johnson's idealized rural landscape, his retreat from the city. The buildings and the landscape, what you see and what you don't see, all reflect Johnson's design vision.

Johnson never claimed to be a "formgiver like Mies van der Rohe." His talent lay in identifying important new ideas and pushing them forward through his own patronage or his legendary influence. Through his own work in architecture and landscape design, he referenced his sources of inspiration as he experimented, often pushing their boundaries. When he first purchased land in New Canaan, he claimed, "Connecticut is a beautiful state, but you can't see it for the trees." Johnson drew inspiration for his country retreat from the meadows of his Ohio childhood, as well as his visits to great eighteenth-century European landscapes. He began a process of "reduction," like an artist shaping clay, taking away the excess in order to reveal the desired form. He cleared away trees to create meadows and distant forests, and carefully placed works of architecture. He respected how the earlier farmers had worked with the site's contours and geography as they placed stone walls. Along with the mature trees, he embraced the stone walls as an organizing element of the site.

Near the base of the drive, the site-specific placement of a concrete sculpture by Donald Judd (1971) forces a curve that now directs your view and positions your approach to the Glass House. Johnson fortified a stone wall near the end of the drive that serves as a hide before the reveal. The driveway ends at a closely cut lawn, with the Glass House on your left and its opposing twin, the Brick House, on your right. These two structures, the Glass House and the Brick House, represent two halves of a whole, with the lawn serving as the center courtyard. At this threshold, no one can direct or dictate how anyone else feels. Johnson believed in the power of architecture to wrap itself around you, bringing you to a very personal, emotional response to space and place. More than words, this guides the experience as you are invited to enter the Glass House. Johnson's quote inspires our approach to interpretation, "I just tell my friends to shut up and look around."

The Glass House expresses Johnson's very personal modernist vision. At The Museum of Modern Art, he introduced modernism to the United States through the exhibition *Modern Architecture: International Exhibition* in 1932. Johnson was familiar with the drawings and model for Mies van der Rohe's Farnsworth House and referenced it as his source of inspiration. However, there are important distinctions—from the traditional organization of the living spaces to classical references—that reveal the Glass House as a very personal work of architecture for one particular geographic place. The Glass House was by and for one person—Philip Johnson. It reveals his interest in the past, present, and future, and his goal to create "a pavilion for viewing nature."

At the center of the house are a fireplace and a seating area featuring furniture designed by Mies van der Rohe. Here, at the invitation of Philip Johnson and David Whitney, great minds convened for conversation. The intimate gatherings at the Glass House launched careers, promoted cultural patronage, and

fostered intellectual transformation. These often saucy, edgy, and challenging exchanges became legendary, and we recognize their enormous influence on art, design, and culture. Former guests include some of today's most esteemed architects, designers, and artists. Guests recall visits to the Glass House and subsequent conversations as seminal influences in their lives and work.

t he living area for the Glass House extends to the promontory, with a view west over a pond, a Pavilion (1962) where Johnson hosted picnics, and the Lincoln Kirstein Tower (1985), dedicated to Johnson's great friend, the founder of the New York City Ballet. Both of these "events on the landscape" represent Johnson's enthusiasm for "safe/danger." Johnson recognized and relished pushing himself and others to the edge, past comfort, as this is where and when we are most receptive to change. Jumping from the shore to the Pavilion, and scaling the tower, forces one into the realm of opportunity offered by uncertainty and risk. Originally, the Pavilion was white, with a gold-leaf interior ceiling; a large water jet in the center of the pond cascaded water onto the Pavilion roof, where it was then channeled into a bubbling fountain. The meadow surrounding the property's pond and the forests beyond were carefully managed. To see this landscape as nature would be similar to assuming that Central Park is the part of New York City that no one has yet developed. Like Central Park, which Johnson called his favorite work of architecture in New York City, the forests, meadows, pathways, and pond at the Glass House reflect a particular design vision for an idealized rural landscape. The architect Robert A. M. Stern recalls, "After enjoying a drink or lunch in the Glass House, Johnson would put his hands on the arms

of his chair and invite, 'Let's go look at art.' He would then lead us across the lawn and up the hill through the meadow. A path didn't begin until we reached the footbridge, on our way to the galleries."

before continuing your stroll, explore the Brick House, the second half of the Glass House. Together, the Glass House and the Brick House offer a lesson in contrasts— glass/brick, open/closed, public/private. The Brick House contains a guest room, reading library, bathroom and all of the mechanical systems that support the Glass House. The guest room ceiling was inspired by the handkerchief ceiling in Sir John Soane's house in London. The walls are luxuriously covered by Fortuny silk fabric. Prints by Brice Marden line the corridor, illuminated by skylights, which connects the three rooms. Dramatic round windows on the east side of the building were inspired by Filippo Brunelleschi's fifteenth-century Duomo in Florence.

Behind the Brick House, the hillside path affords the best vantage point for studying the composition of the Glass House, including the pathways, the Brick House, and the pool (1955). If you can draw a circle, rectangle, square, and triangle, you can sketch the Glass House. It is a Platonic lesson, where truth and beauty are expressed through pure geometric form. The expedition continues to Johnson's galleries, across a springy bridge over a naturalistic ravine, and along a New England lane lined with maple trees.

The Painting Gallery (1965) is a grass-covered mound. The entrance was inspired by the Treasury of Atreus, a tomb located in Mycenae, Greece. As with the rest of the property, Johnson marries a reference to history with a current idea. When Johnson

built this gallery, he was inspired by artists such as Robert Smithson and Walter de Maria, who were using the earth itself as their artistic medium. Inside, as your eyes adjust to the cave-like space, you find yourself in a vestibule where Lynn Davis's photographs and a sketch by Michael Heizer on are on display. Like the enclosure created by white pine trees at the top of the driveway, this vestibule sets you up for the drama of the "reveal" when a press of a switch illuminates the main gallery.

The painting gallery features six large paintings on panels that are part of a rotating system similar to three large poster racks. By physically pushing the panels, you can change what is on view. While only six paintings are on view at any one time, up to forty-two paintings can be stored. Paintings by Robert Rauschenberg, David Salle, Julian Schnabel, Cindy Sherman, Frank Stella, and Andy Warhol are displayed and stored in this space.

Johnson expressed his preference for only looking at one painting at a time. Even though he designed many public museums, he was emphatic, "After fifteen minutes, I've had it!" In his private painting gallery, he could share his collection with his friends, including prominent architects, artists, museum directors, and curators. They would gather to celebrate and discuss new works by established artists, as well as work by emerging artists. Often, after works were shared and celebrated in this gallery, they would be donated to public museums. (Philip Johnson contributed more than two thousand artworks and design objects to MoMA.) Like the Glass House, the Painting Gallery offered a context for "salons,"as great talents and influential friends discussed ideas and new works on view.

The Sculpture Gallery (1970) was inspired by Greek villages, with stairways that take you to intriguing plazas and courtyards. As Johnson remarked, "every street is a staircase to somewhere." The experience of descending the stairs exemplifies Johnson's designed "procession" through space, allowing you to view sculpture from multiple angles and levels. The glass roof, supported by tubular-steel rafters, plays with sunlight and moonlight as it casts dramatic shadows that rake across the gallery. Works by John Chamberlain, Michael Heizer, Andrew Lord, Robert Morris, Bruce Nauman, Robert Rauschenberg, George Segal, and Frank Stella are featured here.

the return stroll along the ridge affords another view of the site's composition, with the Glass House positioned at the center of a constellation of structures throughout the site. The sequence of the site's development offers a timeline of twentieth-century architectural ideas: the Glass House and Brick House convey early modernist ideas, realized in the late 1940s. The pool was added in the 1950s, followed by the Painting Gallery in the 1960s and the Sculpture Gallery in the 1970s. Johnson built his Library Study in 1980 and then, centered in the view from its one window, the Ghost House was added in 1984. At the top of the property, along Ponus Ridge Road, are three vernacular buildings. Johnson and Whitney acquired these buildings as they purchased adjacent property from the 1950s through the 1990s. As with the landscape, they employed the process of "reduction" as they integrated them into the design vision of the site, taking away porches, driveways, greenhouses, a tennis court, and a swimming pool. In 1995, Johnson completed his final building for the Glass House, Da Monsta.

Johnson's final building represents architecture as art. He was inspired by an architectural model for a museum in Dresden that was designed by Frank Stella, an artist and close friend. When Johnson first made a model of this structure, he named it "Dresden Zwei," or "Dresden Two," and presented it to Stella. (Johnson shared an enthusiasm for Frank Stella's work with another close friend, Frank Gehry.) Johnson also cited the early twentieth century work of the German Expressionist Hermann Finsterlin as a source of inspiration. This building, painted red and black as a reference to rural vernacular buildings, was originally planned to serve as a visitor center. When *The New York Times* critic Herbert Muschamp noticed Johnson circling his building, patting it as though it were a living creature, he called it the "monster." Amused by this reference, Johnson named his new building "Da Monsta." Inside, you cannot find a ninety-degree angle as you explore the dramatic, softly lit spaces. From the single, west-facing window, you look directly at the Library Study, where from that building's own single window the Ghost House can be viewed.

The Glass House experience is often transformative, awesome, and inspirational for guests. Exploring the site offers an opportunity that is all too rare—to be engaged in a vision for living where architecture, art, and landscape express beauty and change. Equal in importance to fostering appreciation of the lives and great legacies of Philip Johnson and David Whitney is the Glass House's mission to create programs and experiences that encourage us to take a fresh look at the world—to consider how, through architecture and design, we mediate our relationship with nature. We are all touched by the spirit of this place, which reminds us to take risks, explore new ideas, cultivate talent, create beauty, and find inspiration in our lives each day.

<div align="right">

Dorothy Dunn
Director of Visitor Experience and Fellowships
Philip Johnson Glass House

</div>

" The Glass House is
my 50-year diary. "

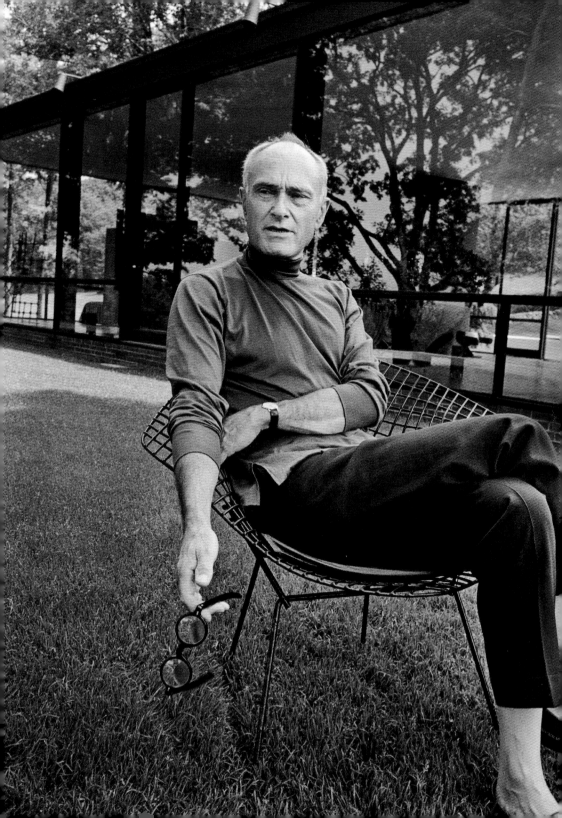

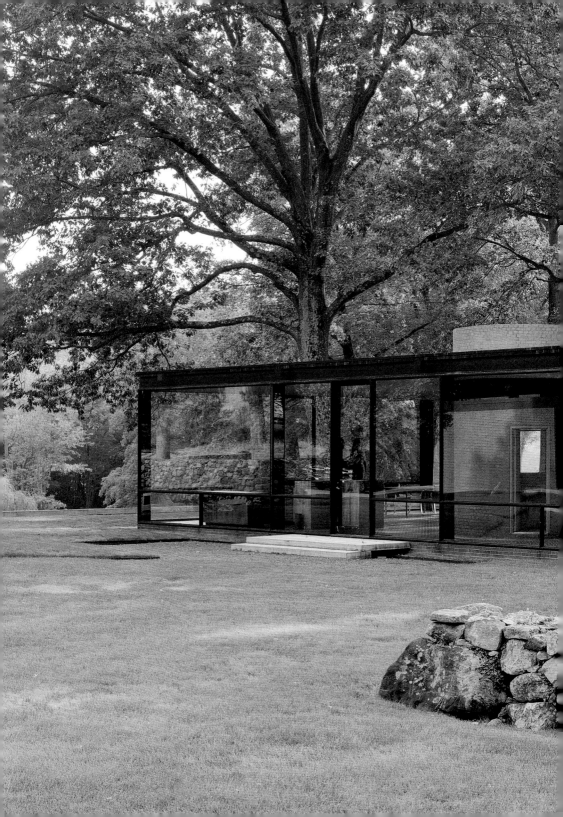

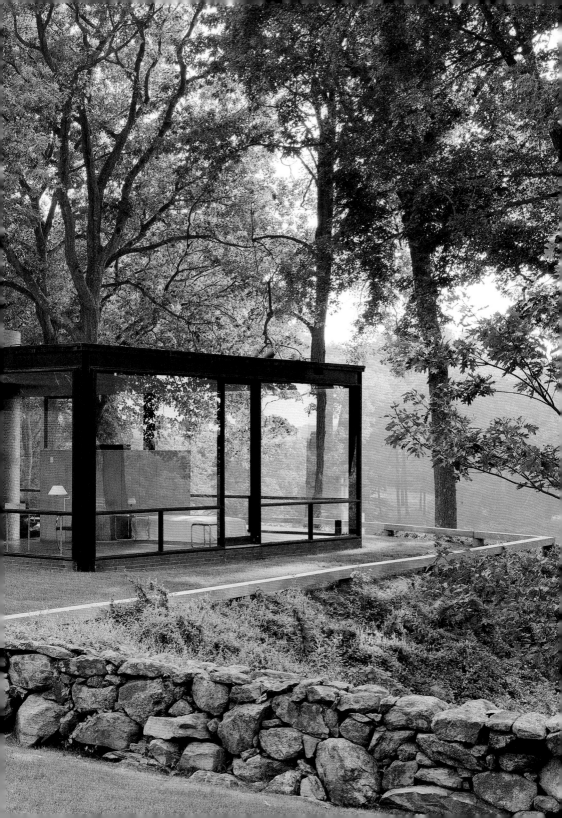

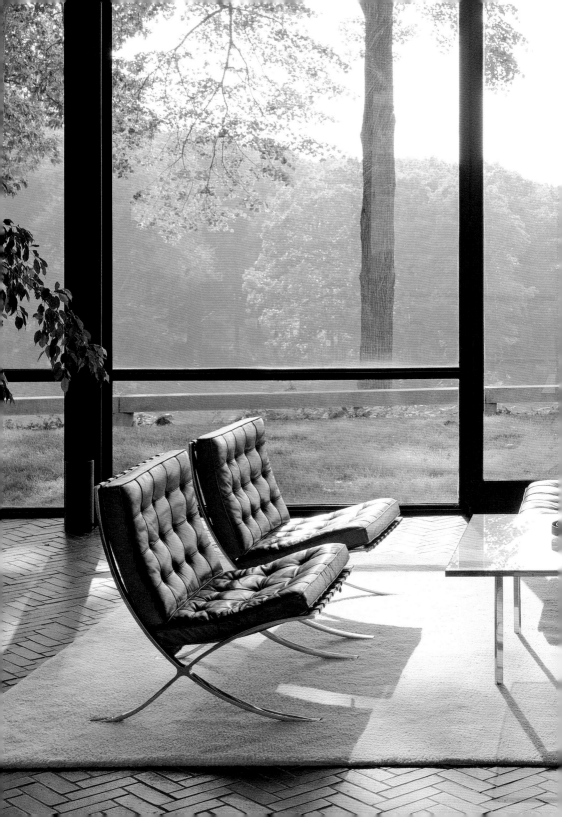

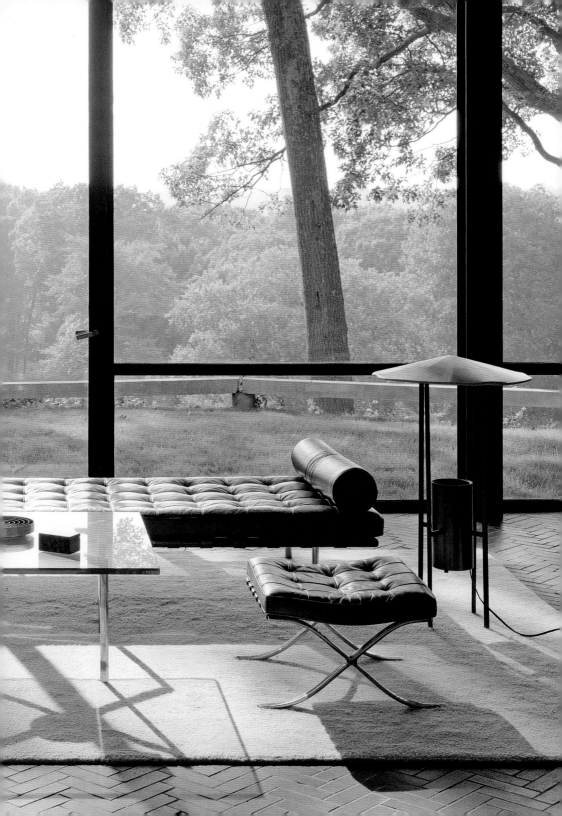

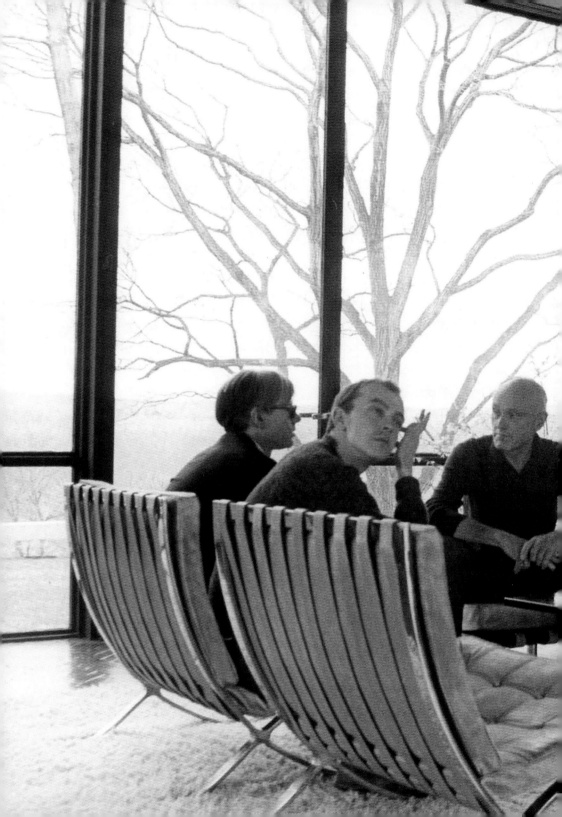

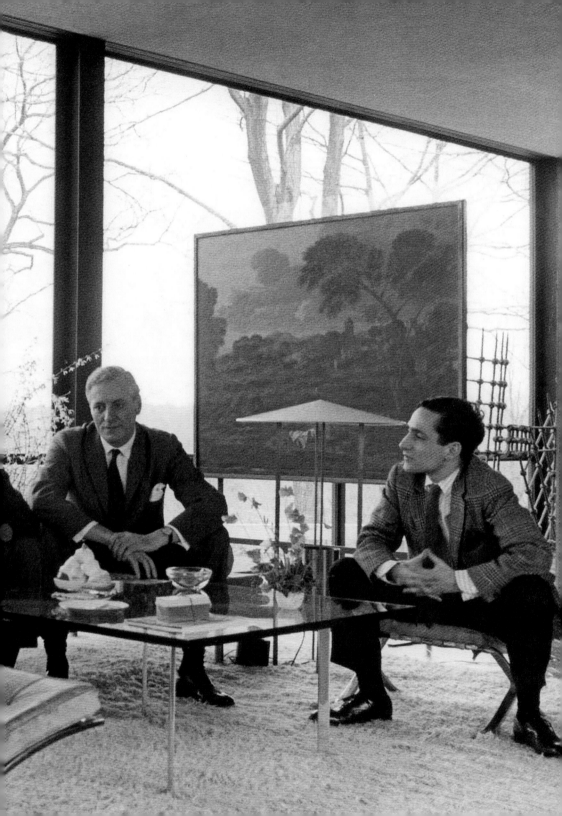

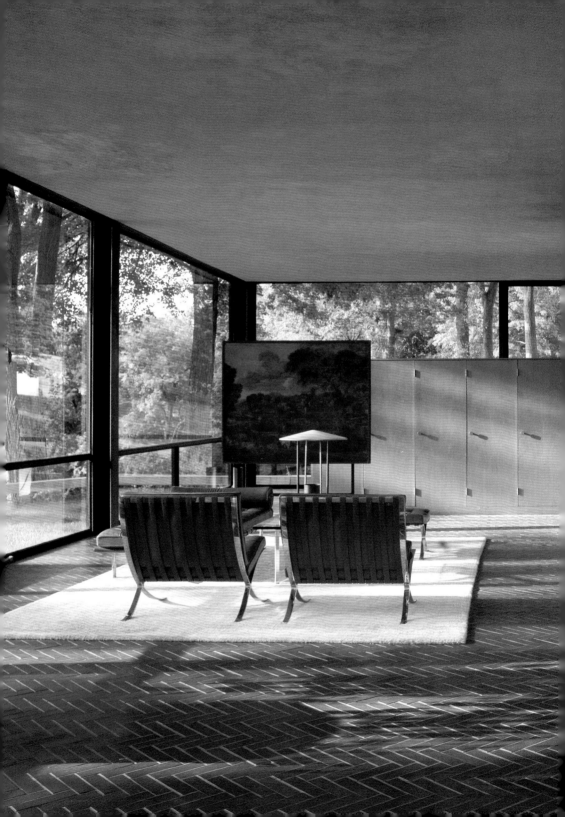

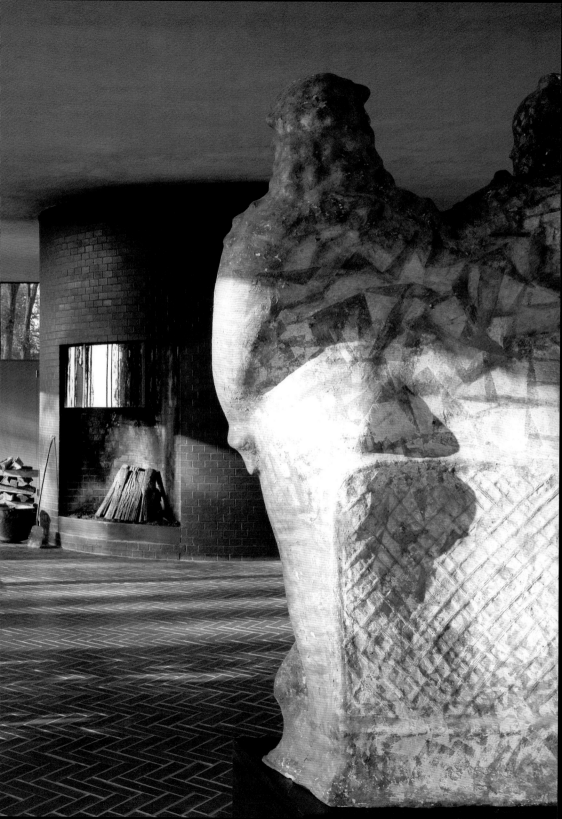

"I am building a pavilion for viewing nature.**"**

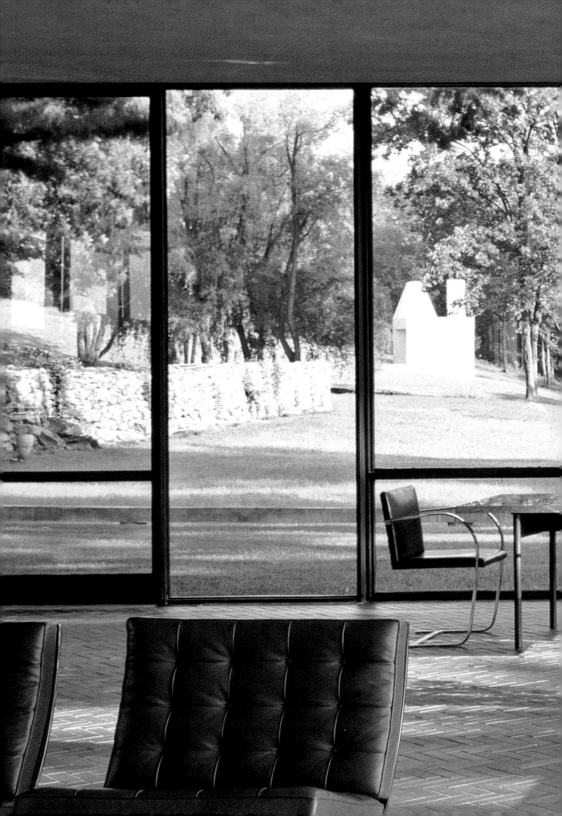

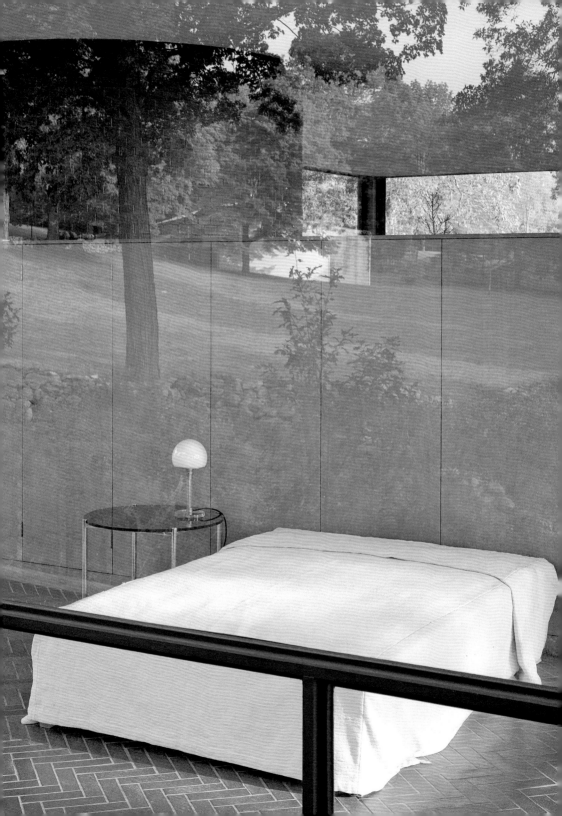

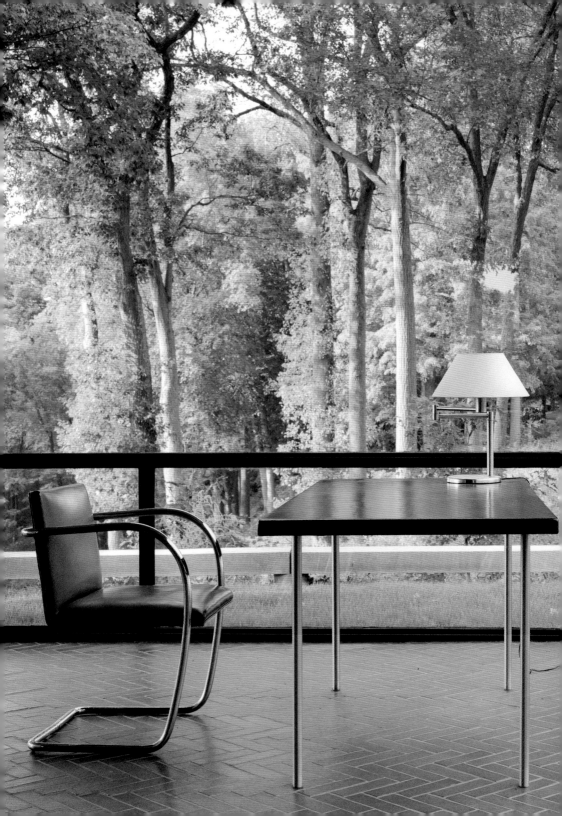

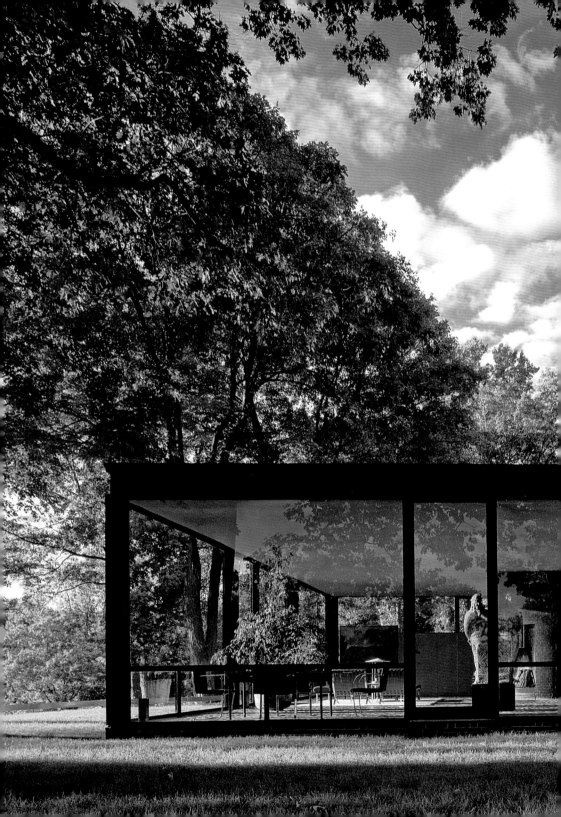

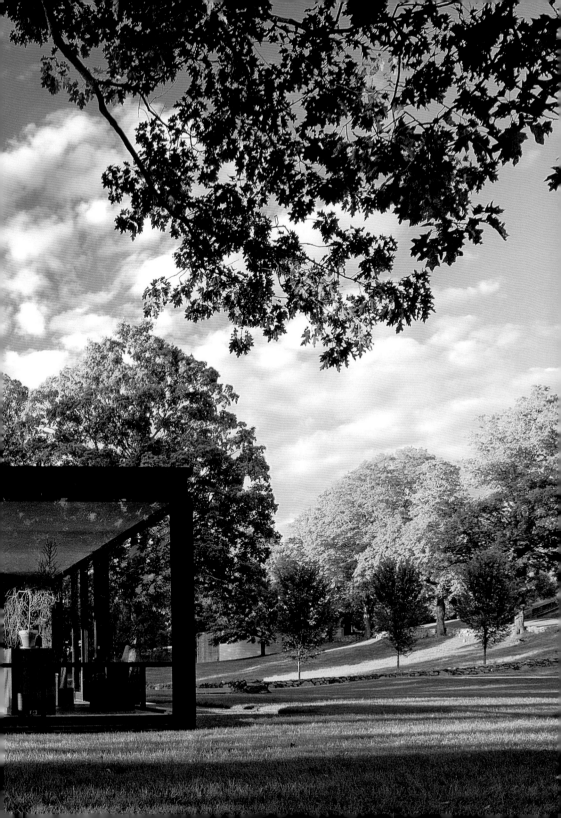

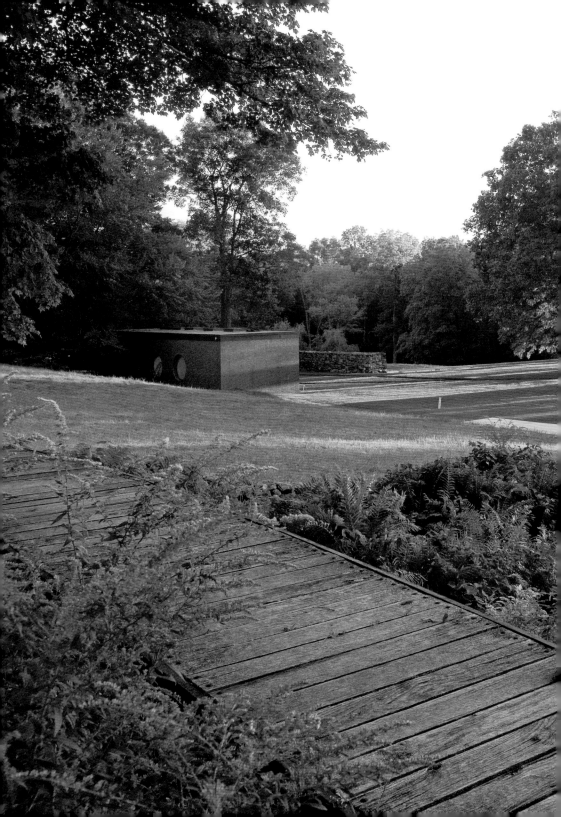

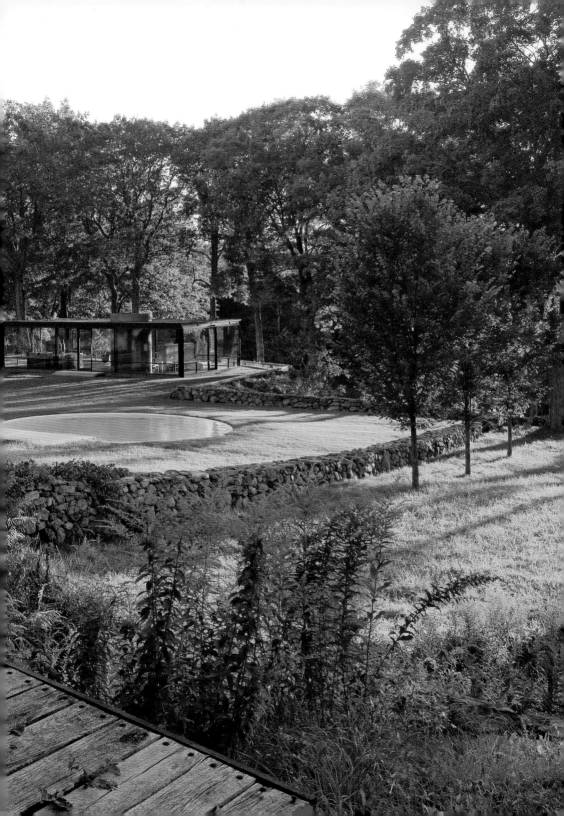

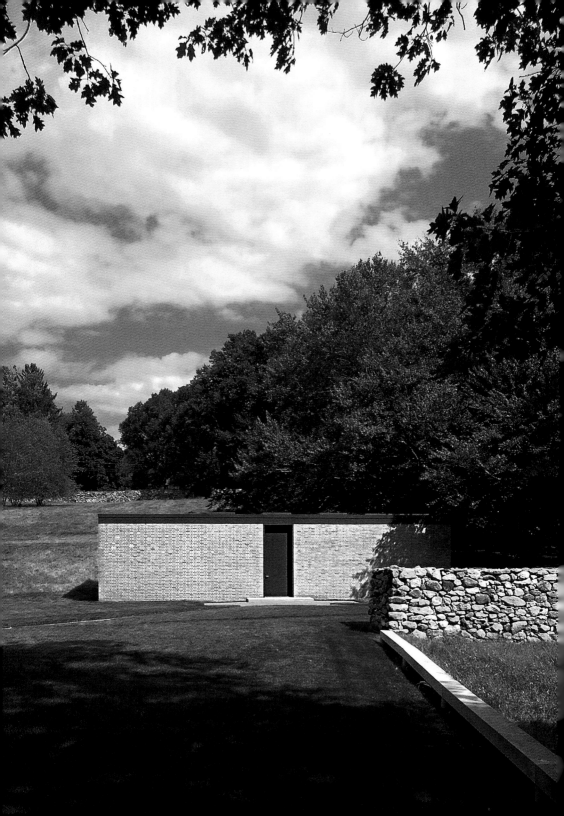

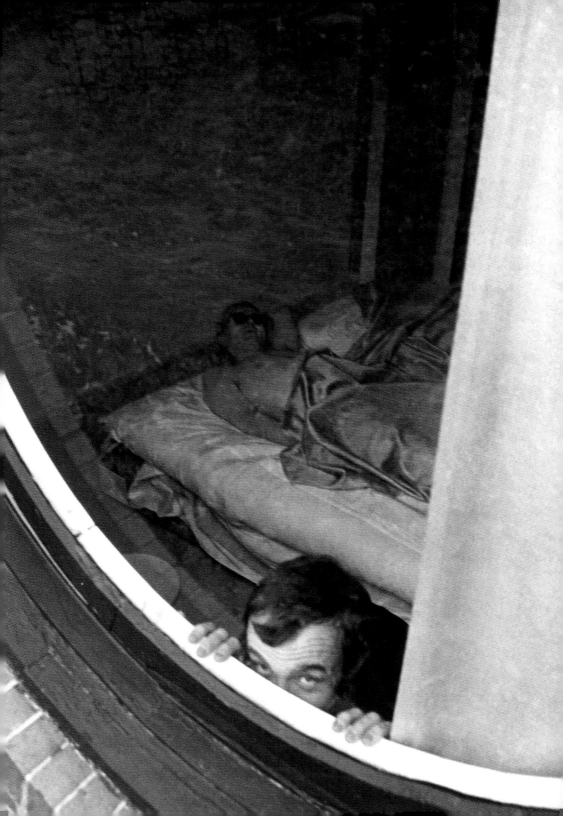

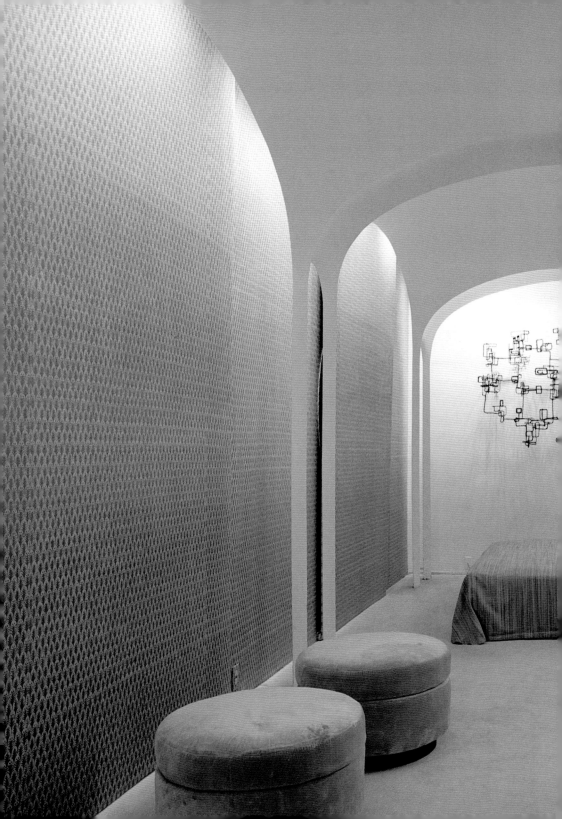

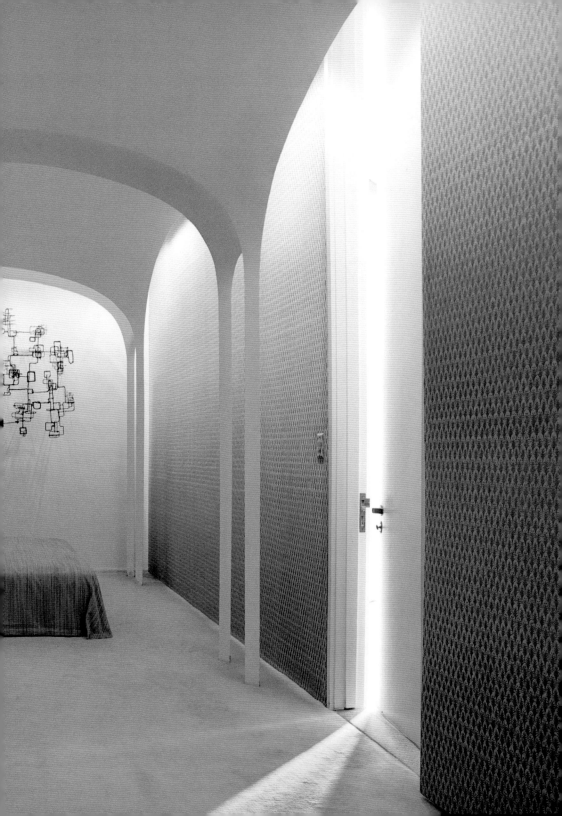

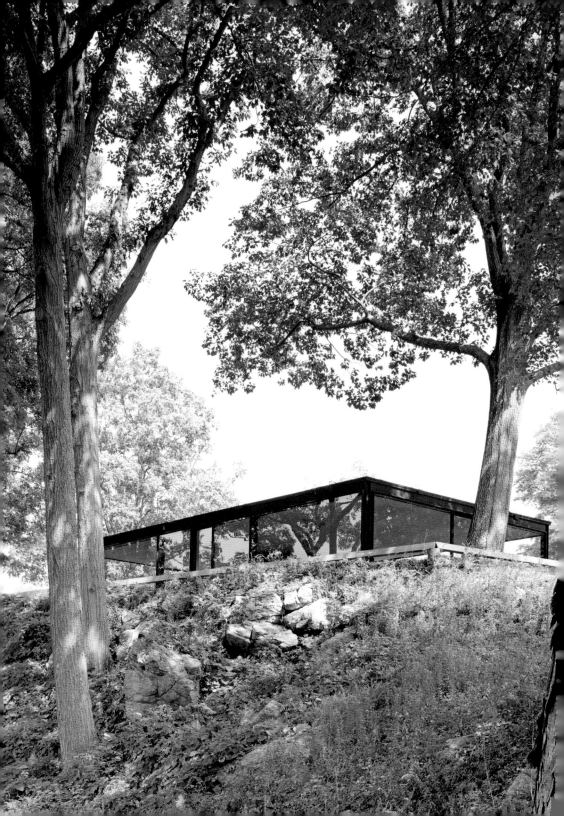

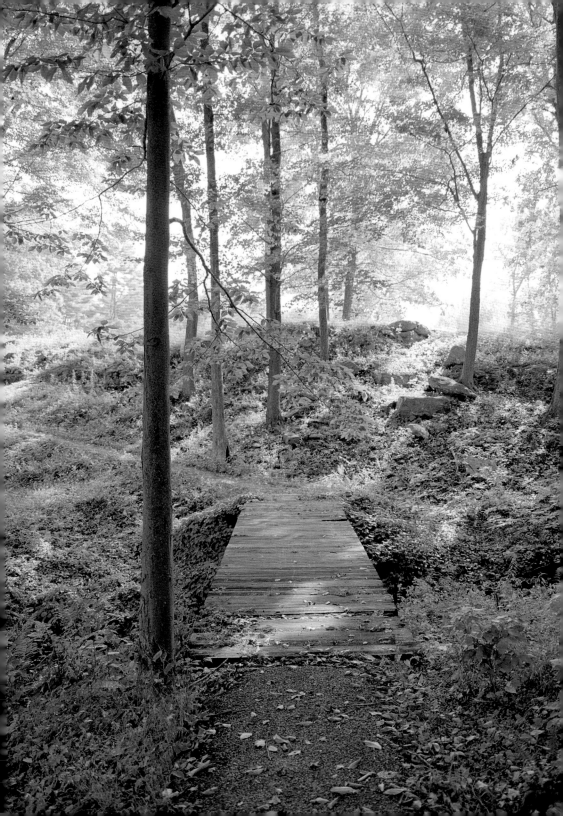

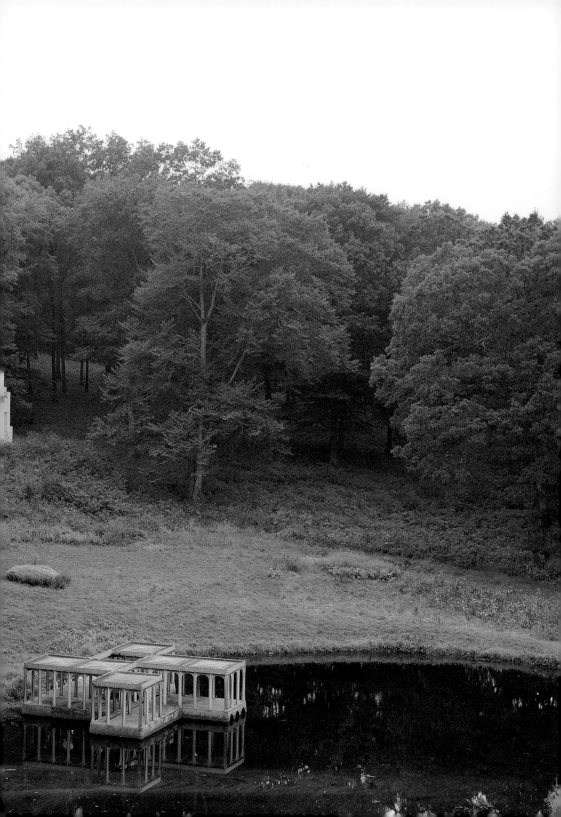

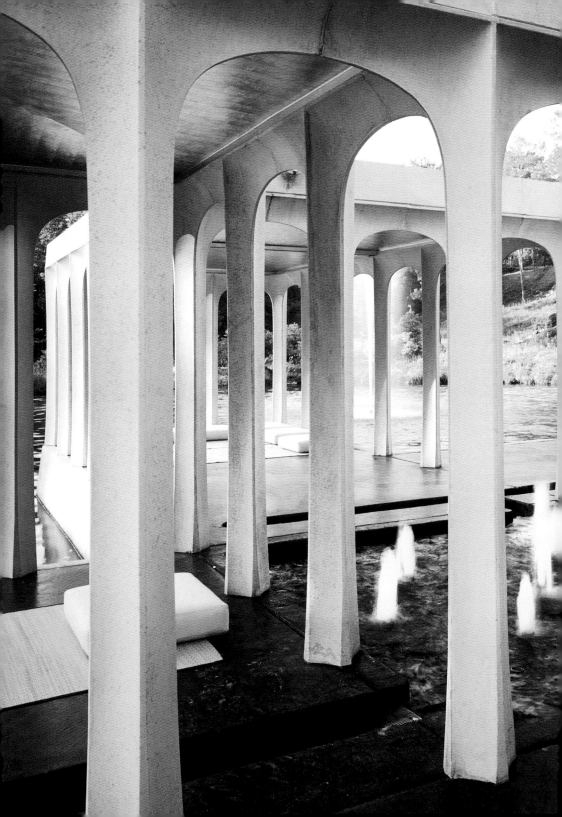

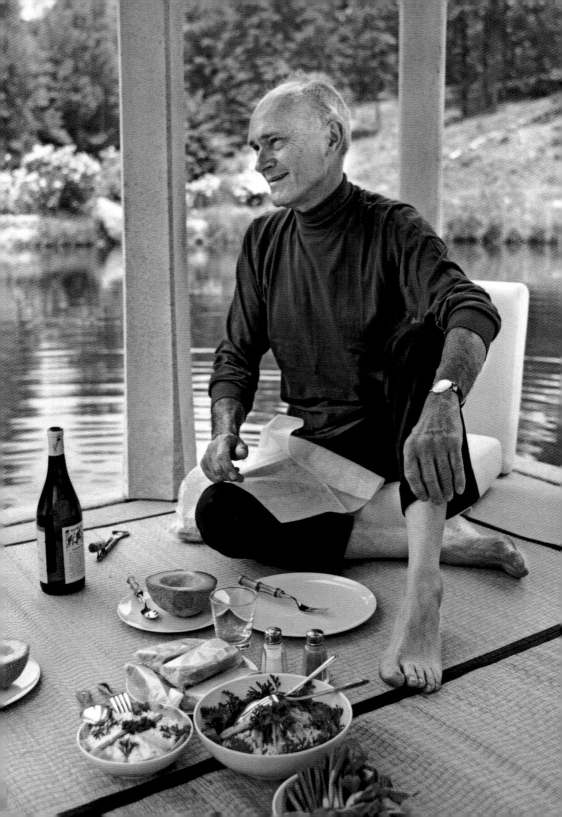

" Form + Structure =
Dance and Architecture "

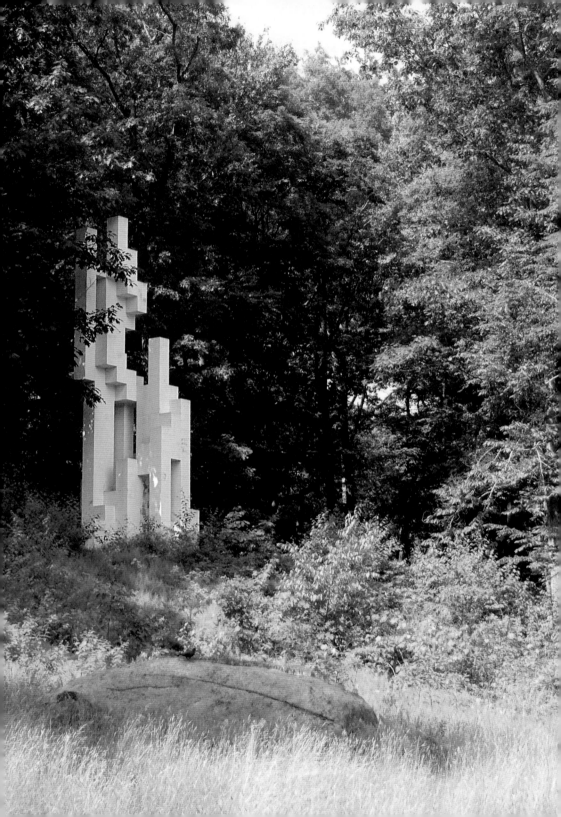

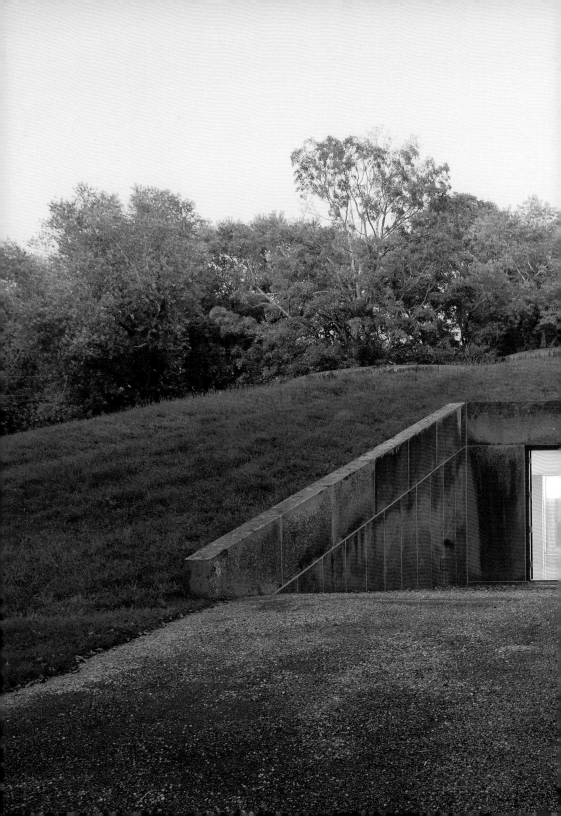

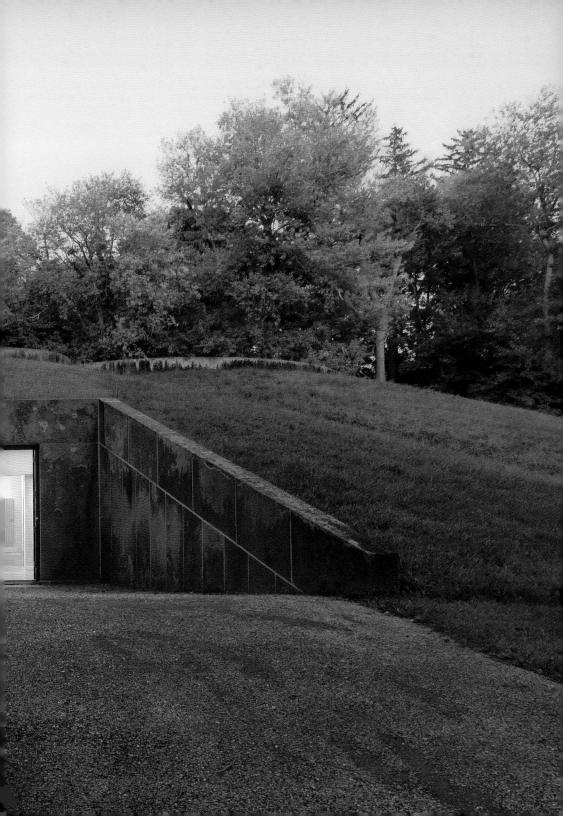

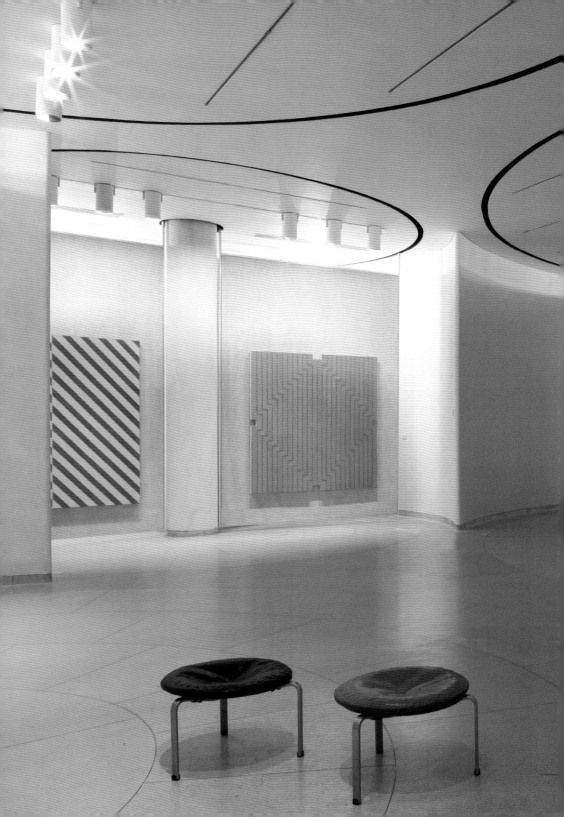

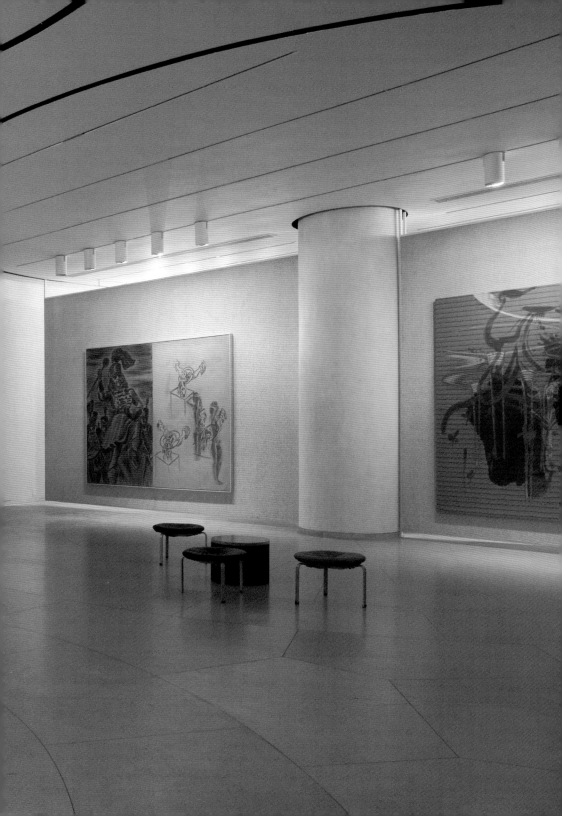

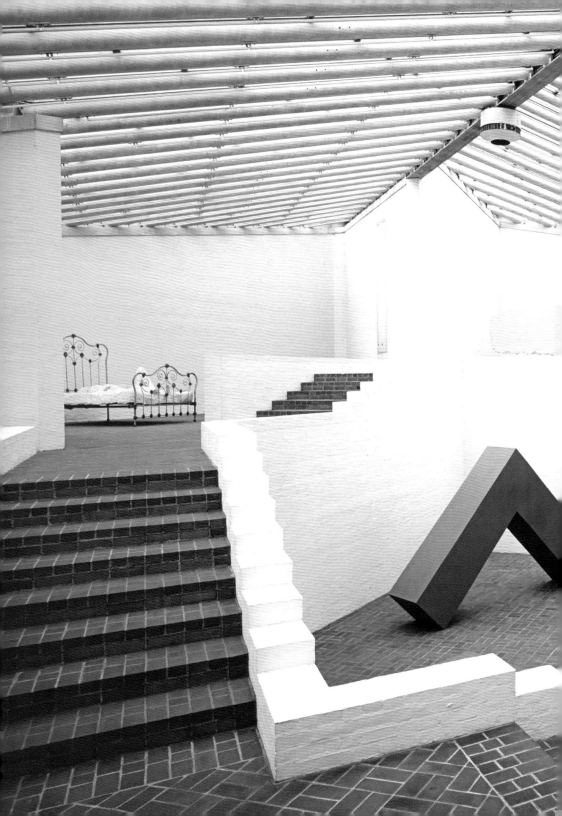

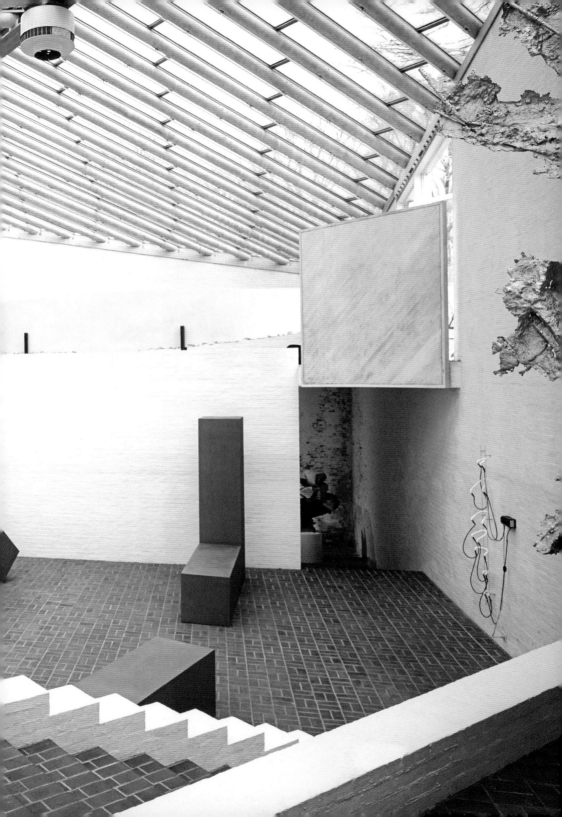

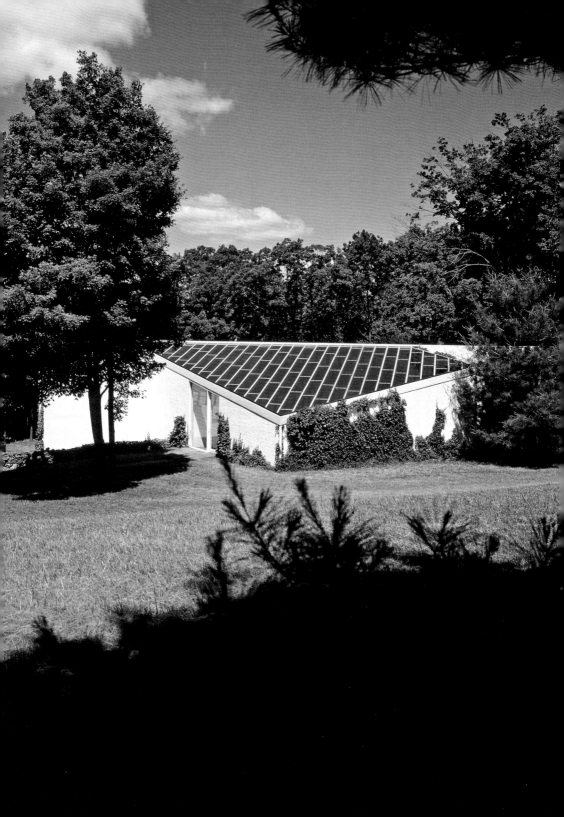

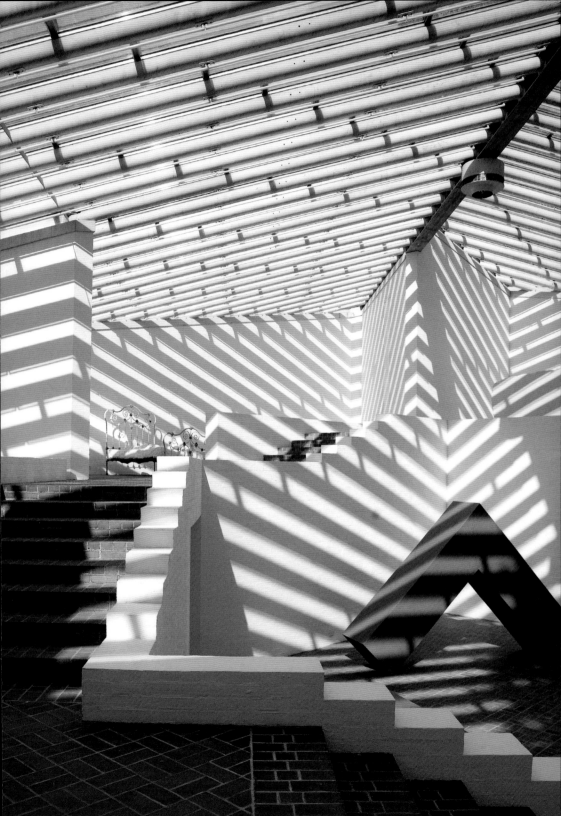

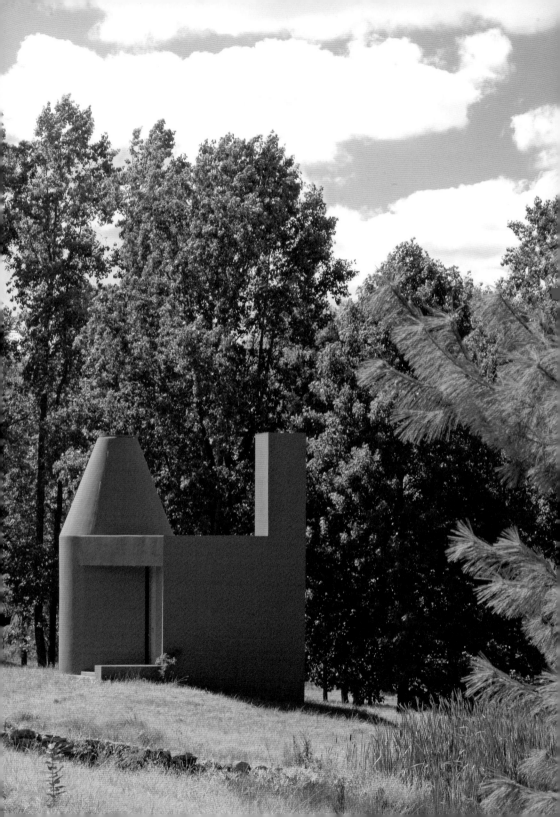

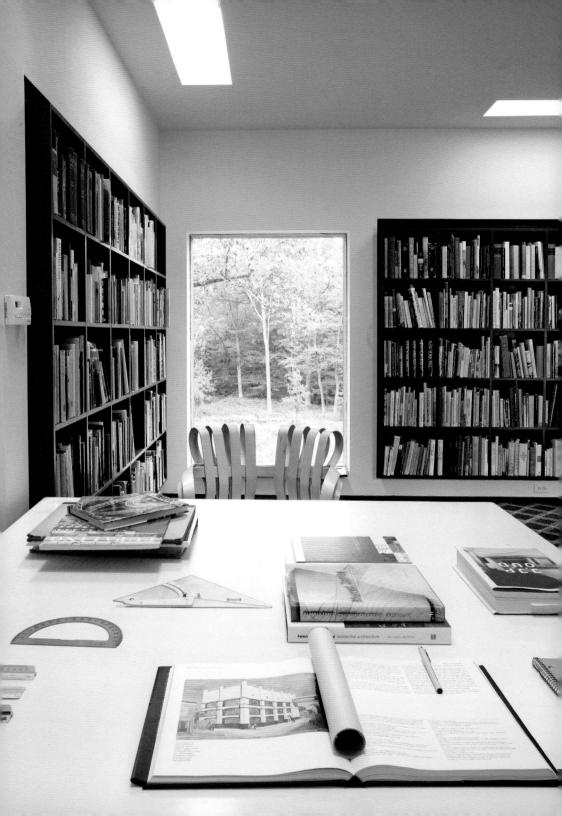

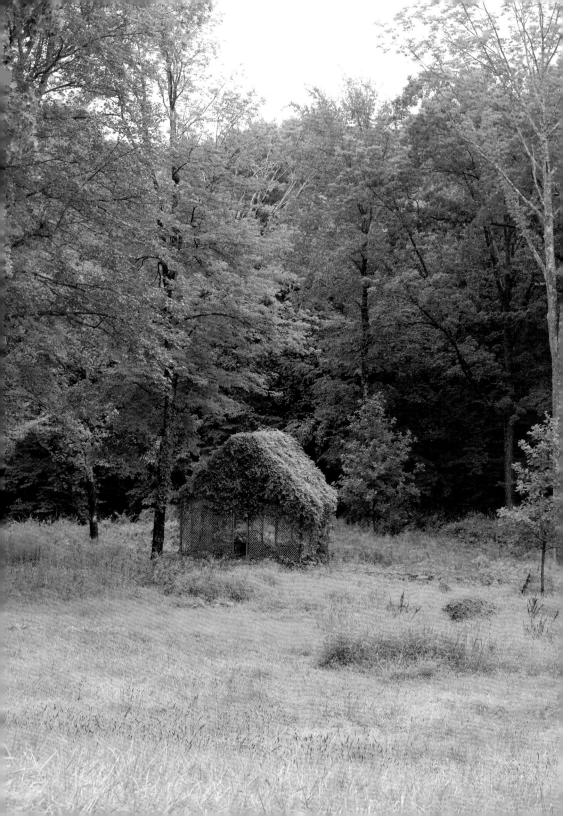

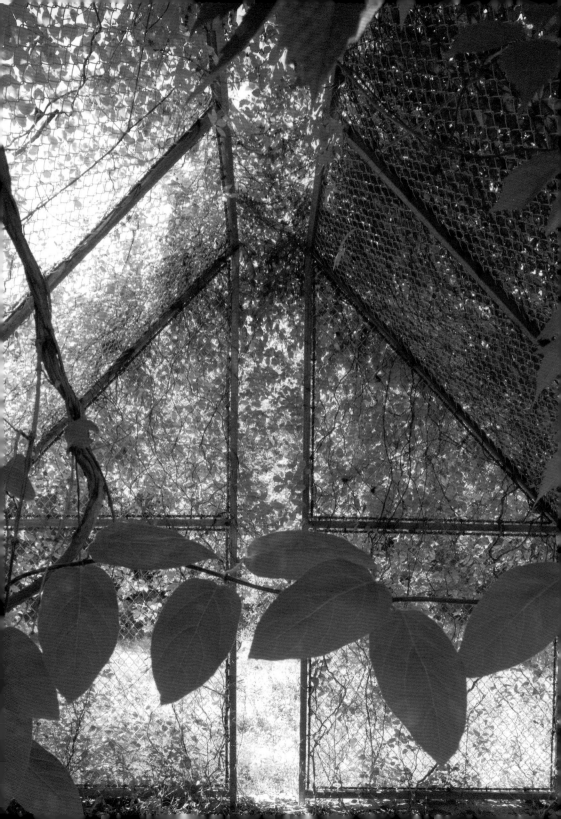

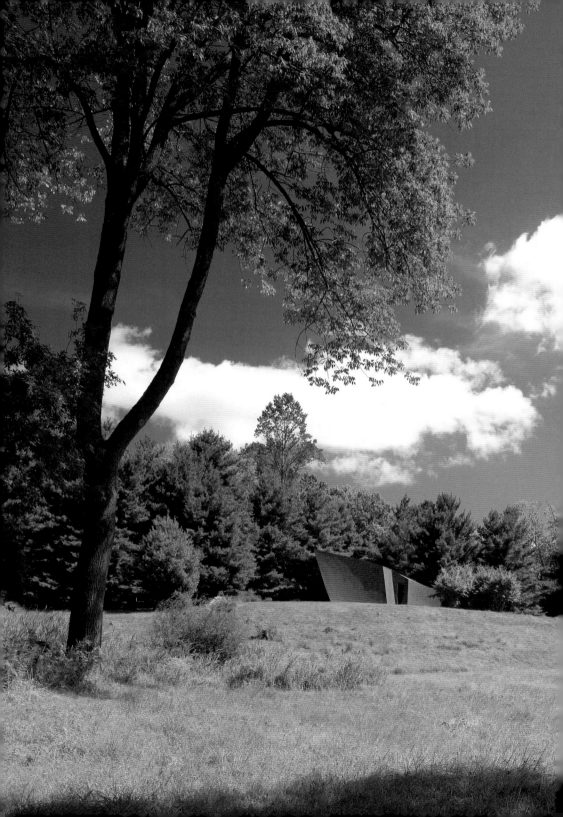

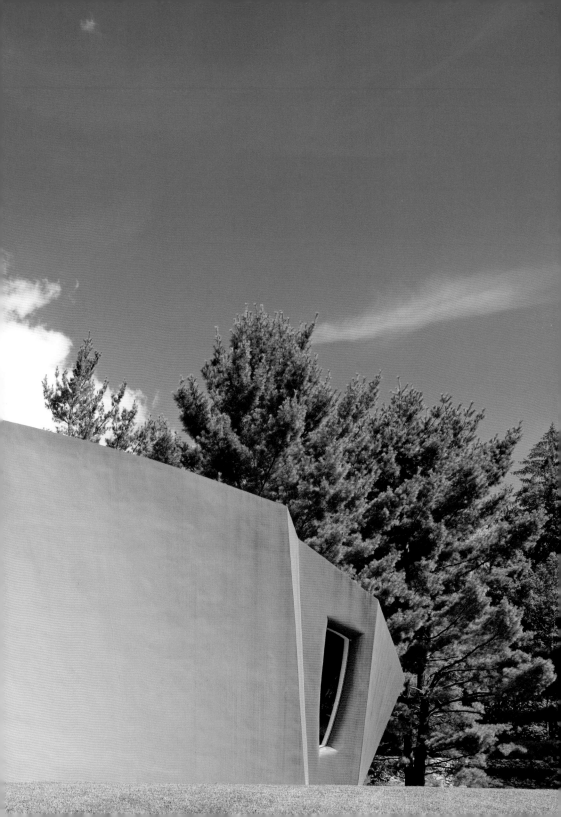

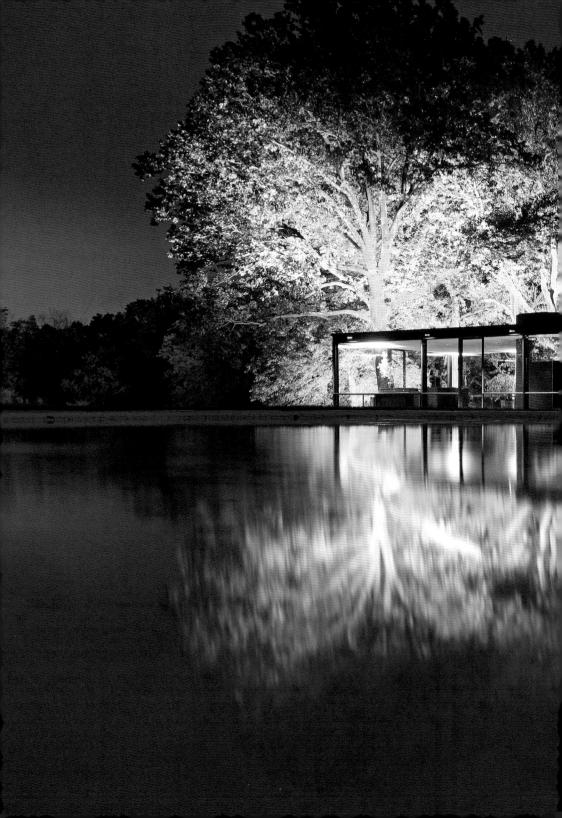

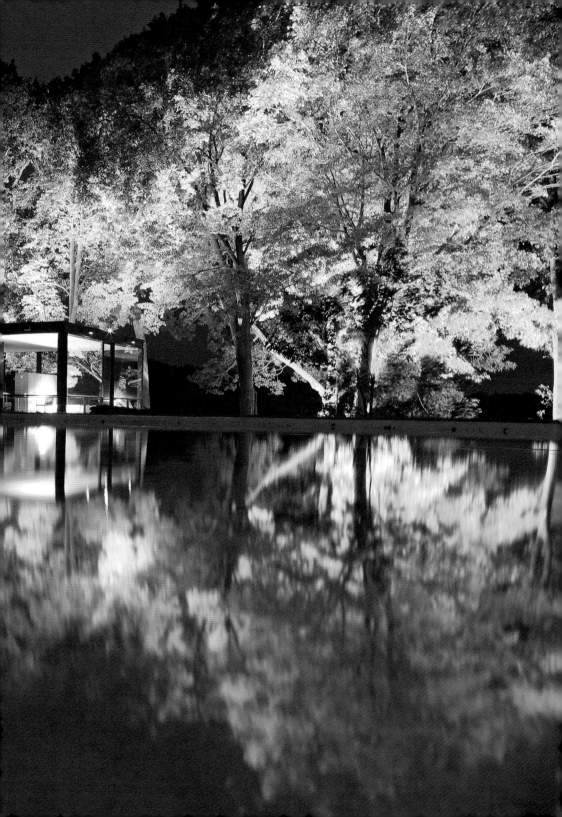

Chronology

1906: Philip Johnson born on July 8 in Cleveland, Ohio

1923: Enters Harvard College, concentrating in history and philosophy

1928–30: Travels throughout Europe visiting modern architects, including J. J. P. Oud, Walter Gropius, Ludwig Mies van der Rohe, and Le Corbusier, at times accompanied by Alfred H. Barr, Jr., and Henry-Russell Hitchcock

1930: Graduates from Harvard College

1930–34: Appointed the first Director of the Department of Architecture at The Museum of Modern Art (MoMA), NY

1932: Organizes *Modern Architecture: International Exhibition* at MoMA with Henry-Russell Hitchcock and publishes *The International Style: Architecture Since 1922*

1939: David Whitney born on March 28 in Worcester, Massachusetts

1940: Philip Johnson returns to Harvard to study architecture under Marcel Breuer and Walter Gropius

1943: Receives Bachelor of Architecture from Harvard University, Graduate School of Design

1945: Begins schematic design of the Glass House

1946: Purchases five acres in New Canaan, CT

1946–54: Returns to position as Director of the Department of Architecture at MoMA

1947: Finalizes design of the Glass House

1948: Groundbreaking for the Glass House and Brick House

1949: The Glass House and Brick House completed

1953: Brick House interior remodeled

1955: Pool completed

1957: Johnson purchases Popestead

1958–2005: Johnson serves as a Trustee at MoMA

1960: Whitney and Johnson meet

1962: Pavilion completed

1965: Painting Gallery completed

Johnson sitting outside on the promontory, 2002. (Courtesy of Richard Payne)

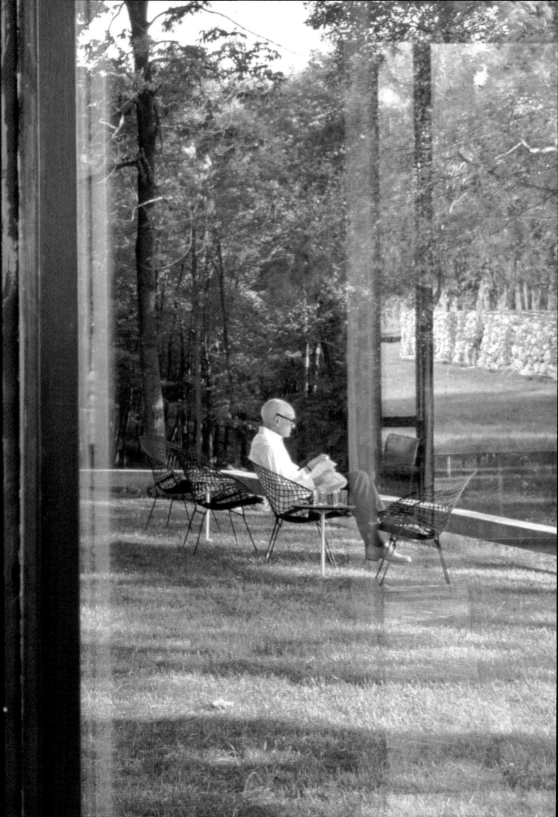

1968–71:	Johnson serves as a Trustee at the National Trust for Historic Preservation
1970:	Sculpture Gallery completed
1977:	Entrance Gate completed
1980:	Library Study completed
1981:	Whitney purchases Calluna Farms
1981–2005:	Calluna Farms remodeled
1984:	Ghost House completed
1985:	Lincoln Kirstein Tower completed; Brick House bathroom remodeled
1986:	Philip Johnson donates the Glass House to the National Trust for Historic Preservation, retaining a life estate
1989:	Whitney Garden at Calluna Farms completed
1990:	Whitney purchases Grainger
1995:	Da Monsta completed
ca. 1996:	Popestead remodeled
ca. 1999:	Grainger remodeled
2005:	Philip Johnson dies on January 25, at age 98
2005:	David Whitney dies at age 66 on June 12; as directed, his New York and Connecticut estates support the National Trust for Historic Preservation's preservation and programming of the Philip Johnson Glass House
2007:	The National Trust for Historic Preservation opens the Philip Johnson Glass House to the public

Driveway meanders towards site-specific sculpture by Donald Judd. (Courtesy of Patrick Hentsch-Cowles)

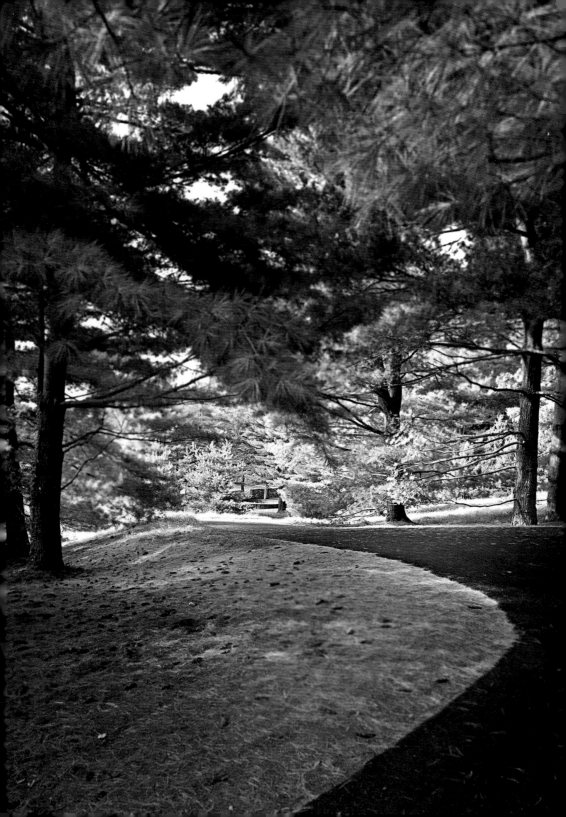

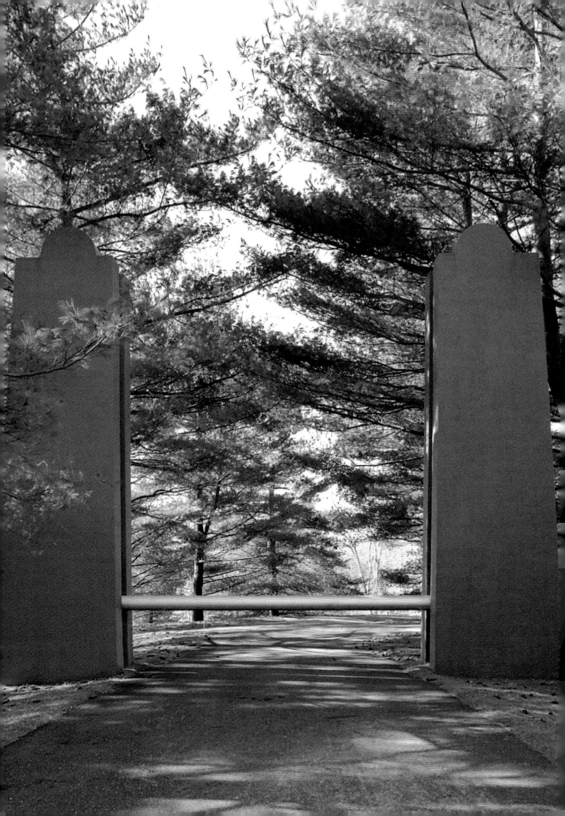

The Glass House

Site plan. (Courtesy of Pentagram)

Philip Johnson sitting on the promontory, 1964. (Courtesy of Bruce Davidson and Magnum Photos)

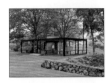

East and north façades, Glass House. (Courtesy of Eirik Johnson)

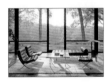

Living room, Glass House. (Courtesy of Eirik Johnson)

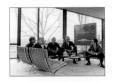

A social gathering at the Glass House, 1964. Guests pictured, from left to right, Andy Warhol, David Whitney, Philip Johnson, Dr. John Dalton, and Robert A. M. Stern. (Courtesy of David McCabe)

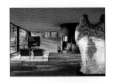

Interior of the Glass House, looking north. Two artworks, the sculpture *Two Circus Women* by Elie Nadelman and the painting *The Burial of Phocion* attributed to Nicolas Poussin, anchor and define the living and dining areas. (Courtesy of Paul Warchol)

Interior of the Glass House, looking south. (Courtesy of Petra Mason)

Entrance gate. (Courtesy of Patrick Hentsch-Cowles)

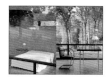

Bedroom, Glass House. (Courtesy of Eirik Johnson)
Study, Glass House. (Courtesy of Eirik Johnson)

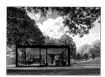

South façade, Glass House. (Courtesy of Paul Warchol)

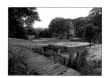

View from eyebrow bridge across the meadow and grass courtyard towards the site's historic core, the Glass House and Brick House. (Courtesy of Paul Warchol)

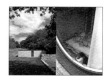

View east towards the Brick House. (Courtesy of Patrick Hentsch-Cowles)
Andy Warhol and David Whitney in the guest bedroom, Brick House, 1964. (Courtesy of David McCabe)

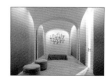

Guest bedroom, Brick House. Johnson commissioned Ibram Lassaw to create the sculpture, *Clouds of Magellan*, for the bedroom. (Courtesy of Dean Kaufman)

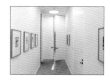

Corridor, Brick House. (Courtesy of Dean Kaufman)

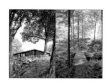

View east towards the promontory. (Courtesy of Eirik Johnson)
Path to the Pavilion. (Courtesy of Dean Kaufman)

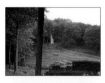

View of Lincoln Kirstein Tower and the Pavilion from the promontory. (Courtesy of Eirik Johnson)

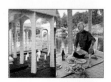

Interior of the Pavilion, 1963. (Courtesy of the Estate of Ezra Stoller and Esto Photographics, Inc.)
Philip Johnson picnicking in the Pavilion, 1964. (Courtesy of Bruce Davidson and Magnum Photos)

Lincoln Kirstein Tower. (Courtesy of Petra Mason)

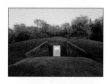

Entrance, Painting Gallery. (Courtesy of Paul Warchol)

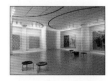

Interior, Painting Gallery. Paintings seen in this photograph are by Frank Stella (left) and David Salle (right). (Courtesy of Paul Warchol)

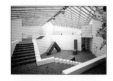

Interior, Sculpture Gallery. Sculptures seen in this photograph (from top, counter-clockwise) are by Michael Heizer, George Segal, Robert Morris, and Bruce Nauman. (Courtesy of Julius Shulman and Juergen Nogai)

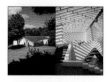

View of the Sculpture Gallery from southeast. (Courtesy of Richard Payne)
The play of light changes constantly throughout the day in the Sculpture Gallery. (Courtesy of Paul Warchol)

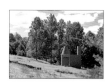

Library Study. (Courtesy of Paul Warchol)

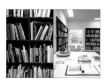

Detail of books, Library Study. (Courtesy of Robin Hill)
Interior, Library Study. (Courtesy of Robin Hill)

Ghost House. (Courtesy of Carol Highsmith)
Interior of the Ghost House. (Courtesy of Paul Warchol)

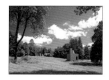

View from the Ghost House towards Ponus Ridge Road. (Courtesy of Paul Warchol)

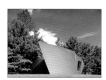

Da Monsta. (Courtesy of Paul Warchol)

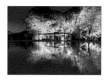

View of the Glass House at night from the pool. Exterior lighting designed by Richard Kelly. (Courtesy of Robin Hill)

National Trust for Historic Preservation

Bibliography

Johnson, Philip. *Writings*. Foreword by Vincent Scully; introduction by Peter Eisenman; commentary by Robert A. M. Stern. New York: Oxford University Press, 1979.

Lewis, Hilary and John O'Connor. *Philip Johnson: The Architect in His Own Words*. New York: Rizzoli, 1994.

Whitney, David and Jeffrey Kipnis, eds. *Philip Johnson: The Glass House*. New York: Pantheon Books, 1993.

Schulze, Franz. *Philip Johnson: Life and Work*. Chicago: University of Chicago Press, 1996.

Weber, Nicholas Fox. *Patron Saints: Five Rebels Who Opened America to a New Art, 1928–1943*. New York: Alfred A. Knopf, 1992.

Acknowledgements

The Philip Johnson Glass House and Assouline Publishing, Inc. would like to acknowledge the Board of Trustees and the Executive Staff of the National Trust for Historic Preservation for their support of the site, in particular Richard Moe, President, and James Vaughan, Vice President, Stewardship of Historic Sites. In addition, we would like to thank Max van Balgooy, Director of Interpretation and Education, for his commentary and review of the content provided in this publication.

The Philip Johnson Glass House would like to thank Ausbert de Arce, Director of Sales and Marketing, and Rebecca Isenberg, Editor, for commissioning and managing the production of this publication. Moreover, we would like to thank Hilary Lewis, the site's Philip Johnson Scholar, for fact-checking, and L. Jane Calverley for copyediting. We especially thank the following individuals and organizations that contributed images to this book: Bruce Davidson and Magnum Photos; Patrick Hentsch-Cowles of digibloom; Carol Highsmith of Carol M. Highsmith Photography, Inc.; Robin Hill of Robin Hill & Company, Photography; Eirik Johnson; Dean Kaufman and Julian Richards, LLC; Petra Mason; David McCabe and Susan Cipolla; Richard Payne and Amy Ladner; Michael Bierut, Jim Biber, and Yves Ludwig of Pentagram, New York; Julius Shulman & Juergen Nogai; the Estate of Ezra Stoller and Esto Photographics Inc., and Paul Warchol of Paul Warchol Photography, Inc.

Lastly, Assouline would like to thank Christy MacLear, Executive Director, and Dorothy Dunn, Director of Visitor Experience and Fellowships, for their texts; in particular, Christy for her leadership and vision; and Dorothy for developing the tour on which the essay is based. We would also like to thank Irene Shum Allen, Curator and Collections Manager, for shaping and editing the book.